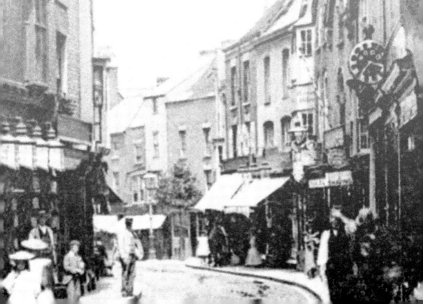

C000088718

LEOMINSTER
HISTORY TOUR

First published 2017

Amberley Publishing
The Hill, Stroud,
Gloucestershire, GL5 4EP
www.amberley-books.com

Copyright © Malcolm Mason, 2017
Map contains Ordnance Survey data
© Crown copyright and database right
[2017]

The right of Malcolm Mason to be
identified as the Author of this work
has been asserted in accordance with
the Copyrights, Designs and Patents
Act 1988.

British Library Cataloguing in
Publication Data.
A catalogue record for this book is
available from the British Library.

ISBN 978 1 4456 7312 7 (print)
ISBN 978 1 4456 7313 4 (ebook)

Origination by Amberley Publishing.
Printed in Great Britain.

INTRODUCTION

Set in the rich farmland of Herefordshire, Leominster grew as a market town for the produce of the surrounding countryside and a centre for manufacturing and trades. The town has enjoyed periods of great prosperity but, as conditions changed, it has also suffered times of great hardship. This rich history is written into the buildings and fabric of the town. It is not just in the grand buildings such as the priory or the Grange that this story is told, but also in the many half-timbered houses and the fine Georgian frontages that are a living reminder of what the town is and how it came to be. Its charm lies in buildings that are little tampered with, a feature that makes the town a rarity.

The history of a town is also written in what has been lost, and the pictures in this book reveal a fascinating insight into the process of change. Some of these losses have been to redevelopment schemes, such as the creation of a ring road; others have demolished to clear 'slums' (often timber-framed buildings of great character), while some have gone for the flimsiest reason of all: they were just old fashioned. Undoubtedly, some of the views in the photographs have suffered from these losses, and are the poorer for it.

Change is inevitable, and Leominster is adapting to the future by developing a new role as a distinctive trading hub and the centre of an expanding tourist trade. This has met with some success, and the *Sunday Times* recently named the town as one of the best places to live in the west midlands. I hope the photographs in this book will help readers to discover something of Leominster's unique appeal.

ACKNOWLEDGEMENTS

I would like to thank Richard and Mary Wheeler, Robert Oliver, the trustees of Leominster Museum, and Susan Baker of Watson's Motors for their invaluable help in sourcing images for this book.

For historical sources, I am indebted to the extensive body of work published on Leominster by both Eric Turton and Norman Reeves. In addition, publications by the Leominster Historical Society and Duncan James, Tim Ward, Ron Shoesmith and Roger Barrett, and Alan Brooks and Nikolaus Pevsner have provided a great deal of valuable background information.

KEY

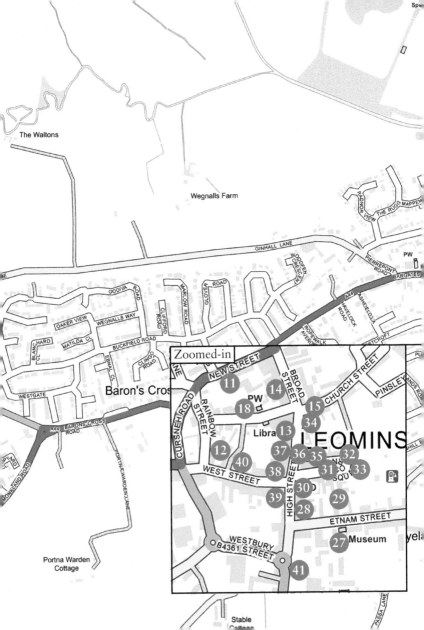

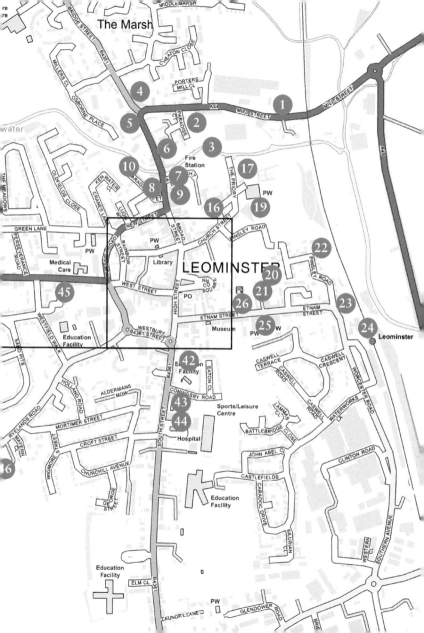

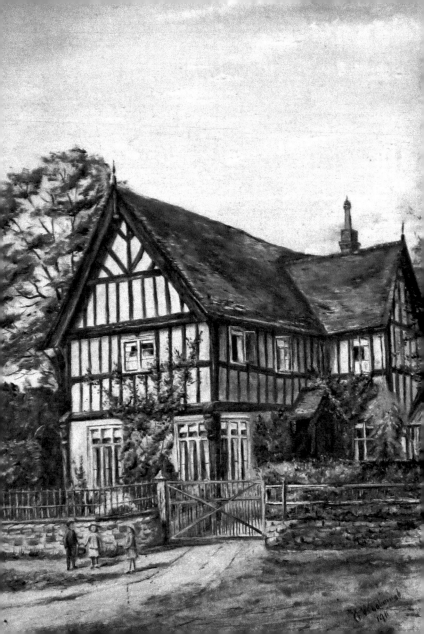

1. 'POPLANDS' IN MILL STREET

Built at the turn of the seventeenth century, this house is thought to take its name from the 'Popeland Turnpike' – the gate used to collect tolls at the southern end of Mill Street. This area was once a meeting point for the town's Baptists, and they surely would not have approved of the fact that from 1790 to around 1859 this was a public house – the Old Harp Inn. This painting (on the left) by G. Woolnough (1911) in the Leominster Museum shows this house as a private residence – a use it still retains.

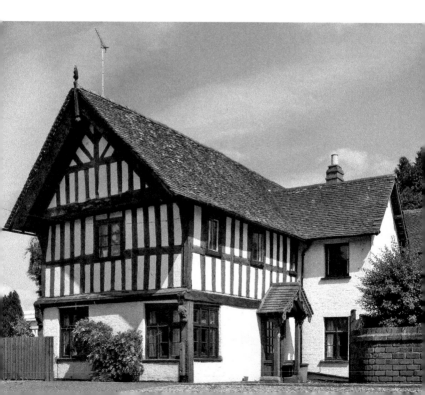

2. MILL STREET

The photographer in the early 1900s was standing with his back to the Corn Mill, which gave the street its name. In the foreground is the weir used to divert the stream to the south when the mill was not in use. This was all removed as part of a flood-control scheme. Many of the houses have also been changed or demolished, including the one on the right with the occupant in the doorway.

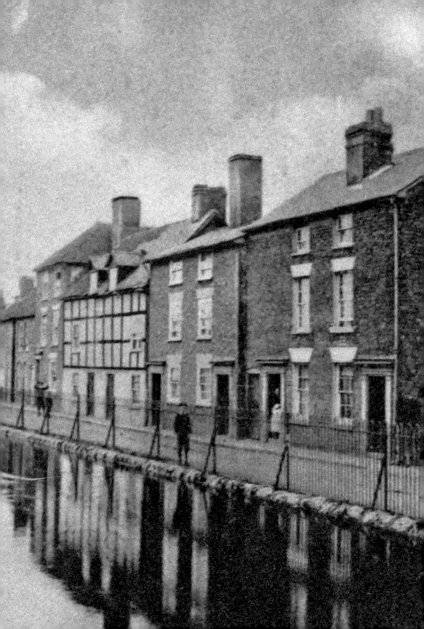

3. THE PRIORY CHURCH ACROSS THE KENWATER

This pleasing view has featured on many postcards over the years. Despite the loss of the meadows bordering the river, the footpath is still open to walkers. Accessed from Mill Street, it leads to the well-maintained bridge still proudly proclaiming its manufacture by the Worcester Foundry in 1844.

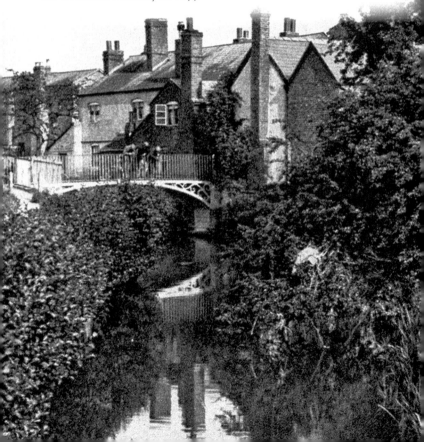

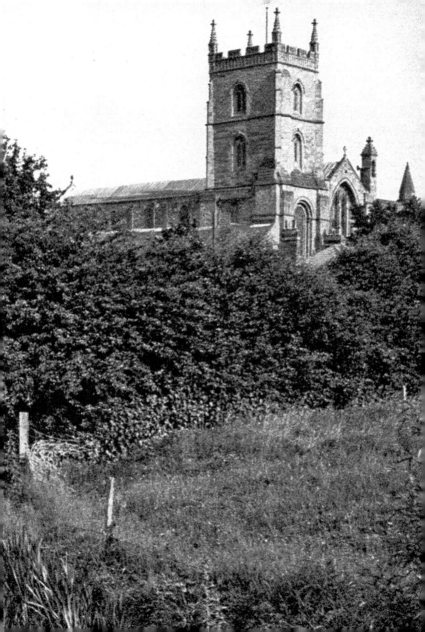

4. BRIDGE STREET

The children in the centre are standing next to the railings enclosing the mill race from Marsh Mill, just visible in the far distance. The railings and the mill race were removed some time ago, but the mill was only demolished recently. On the far left is the Old Tan House, one of the three tanneries in this area placed there to take advantage of the copious quantities of water needed to wash the leather.

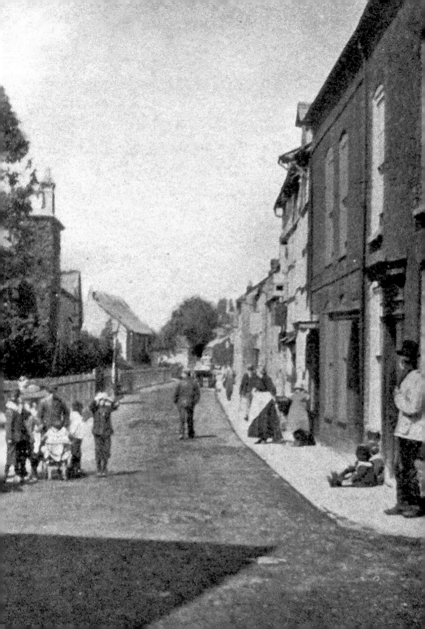

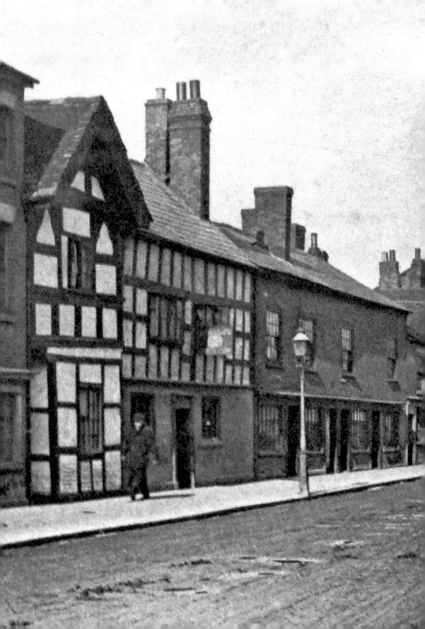

5. THE NORTHERN END OF BRIDGE STREET

Although certain key buildings remain, many interesting houses have disappeared from this view. The loss of the group on the left is particularly noticeable, recorded in the 1930s as dating from the seventeenth and early eighteenth centuries. At least the distinctive house on the far left, built in around 1400, has been preserved.

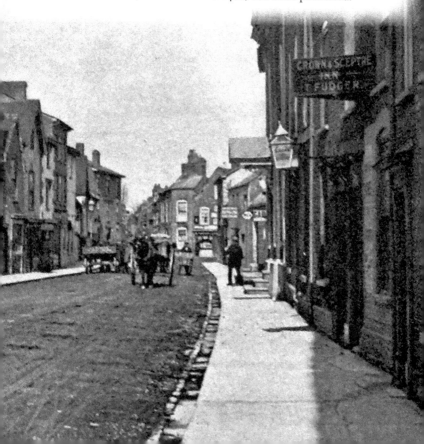

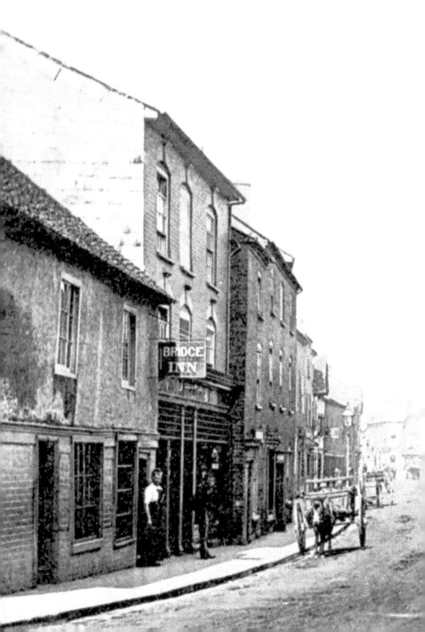

6. THE SOUTHERN END OF BRIDGE STREET

In the late 1800s Bridge Street, below the Kenwater Bridge, was home to a number of pubs – ideally placed to fortify travellers. The Bridge Inn was open between around 1850 and 1910, and beyond that was the Cross Keys, with its sign just visible to the left of the street light. The other pub in the picture is the Crown & Sceptre, at No. 22 on the right.

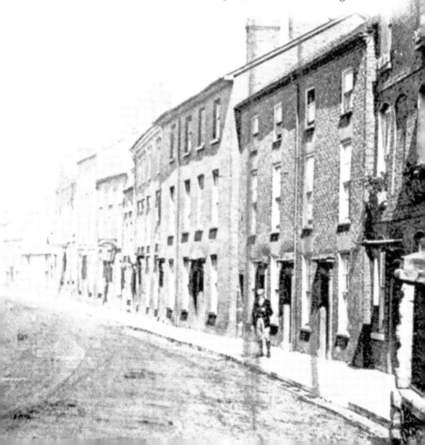

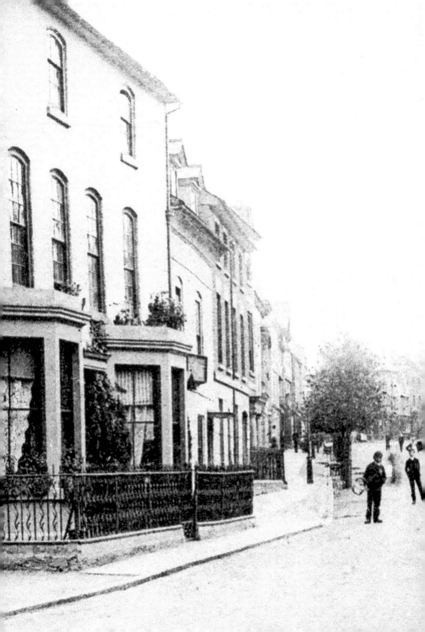

7. BROAD STREET

This photograph of Broad Street must have been taken after 1870, when the old house on the left acquired fashionable Victorian bay windows to enliven its Georgian façade. Since the building of the inner ring road, this area of Broad Street feels separated from the upper one-way part of the street.

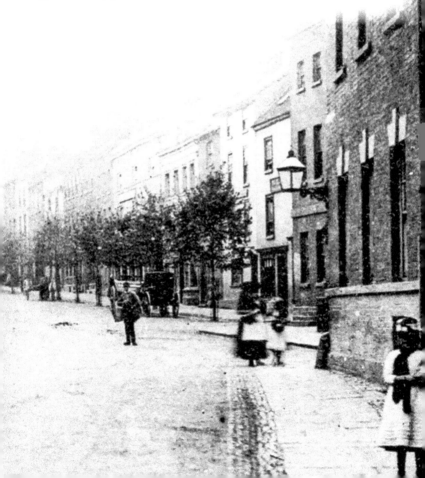

8. PINSLEY HOUSE

Looking very much worse for wear in this picture from the early 1900s, this Georgian house has been lovingly restored, and is now run as a guesthouse. Many of the original features have survived, including the name plaque on the corner and iron rings on either side of the main door.

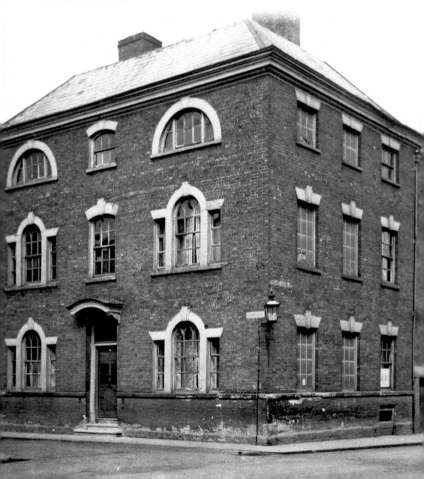

9. BIRD IN THE HAND, BROAD STREET

This pub was first recorded in 1780 when Mrs Ann Colcomb was the owner. In the photograph landlady Mrs Edwards and her daughter pose with Nell the dog for the photographer shortly before the licence was relinquished in 1927. The building now houses a kitchen design company.

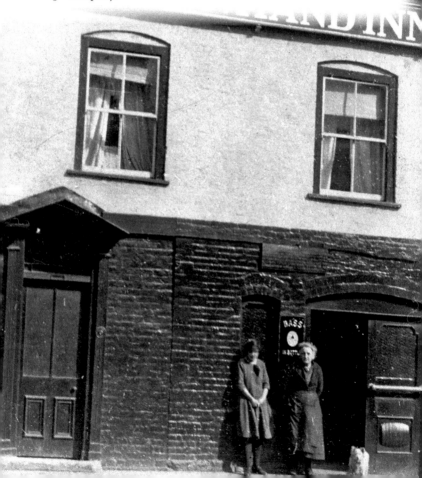

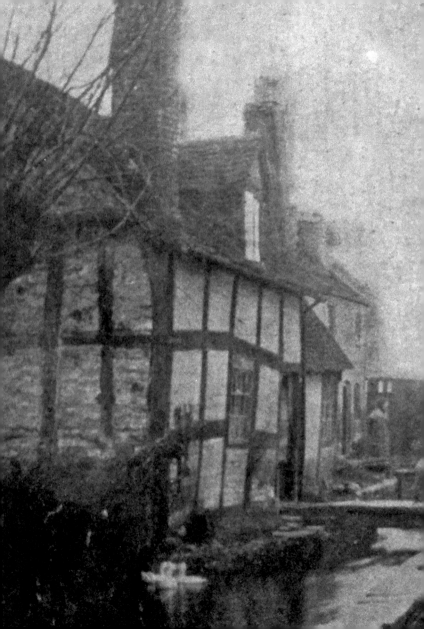

10. VICARAGE STREET

One hundred years ago, Vicarage Street, with its little cottages set on each side of the open Pinsley Brook, provided one of the most picturesque views in the town. Unfortunately the cottages have been demolished, the river covered over, and all replaced by a car park.

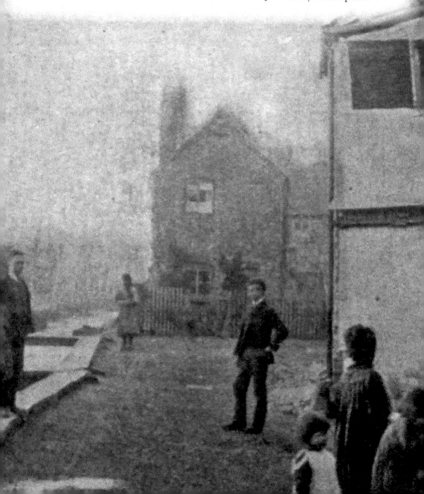

11. NEW STREET, LATE 1800s

New Street was a busy community with many shops, tradesmen and lodging houses. In the centre of the photograph, with a flagpole, is the drill hall where the town's Territorials mustered to march off to both world wars. This is flanked by an interesting mix of old buildings, including the old borough goal; all of them were demolished to make way for the inner relief road in the 1970s.

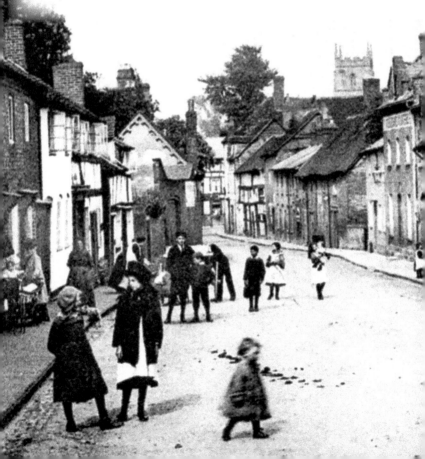

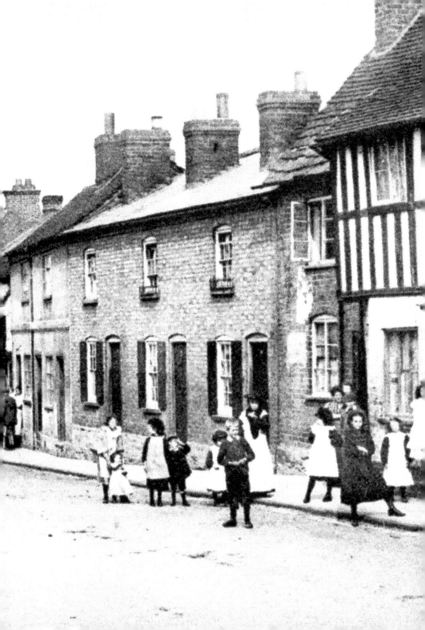

12. HINTON'S STORE, RAINBOW STREET

Hinton's are a long-established trading family in Leominster. George Felton Hinton issued the souvenir mug (inset) when he opened his agricultural merchants in Rainbow Street in 1885. At the time of the main photograph in the early 1990s, the building housed a social club. It retains many reminders of its past, including most of the signage and even the pulley used to raise sacks to the upper floor.

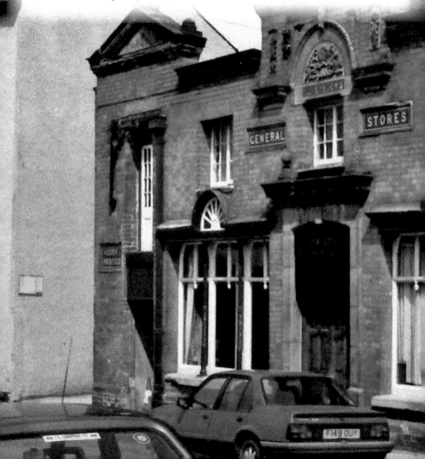

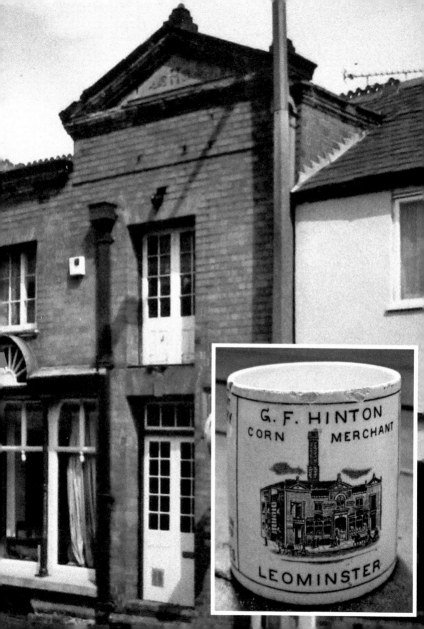

G. F. HINTON
CORN MERCHANT
LEOMINSTER

13. BURGESS STREET

The presence of two Leominster borough policemen in this rather fuzzy photograph suggests it dates from the late 1880s, after the police station moved here from New Street. At the time of this photograph, the street held three chapels. The Presbyterian (Congregational) with the spire, and across the road the old Wesleyan, which was later replaced by a new Wesleyan chapel to the right of where the group of children are standing.

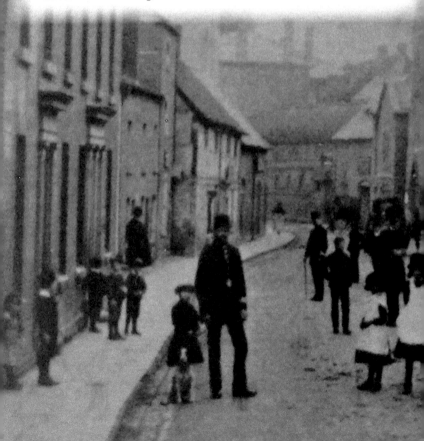

14. BROAD STREET AND THE TOWN HALL

Built by the king's carpenter, John Abel, in 1633, the Market House dominated the top of Broad Street. Removal to its present site at the Grange in 1855 allowed the building of a new Town Hall (on the right in the inset) by the same architect as the Corn Exchange. The semicircular 'Hen Pen' (left), built on the site of a cockfighting pit, was originally part of the old market.

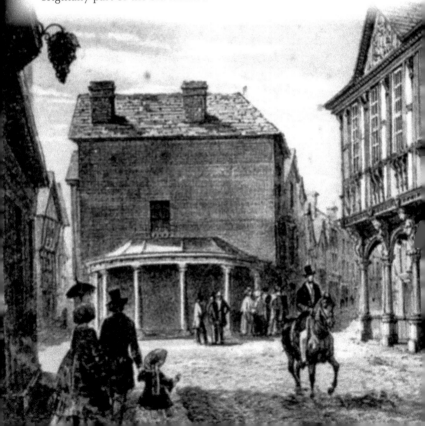

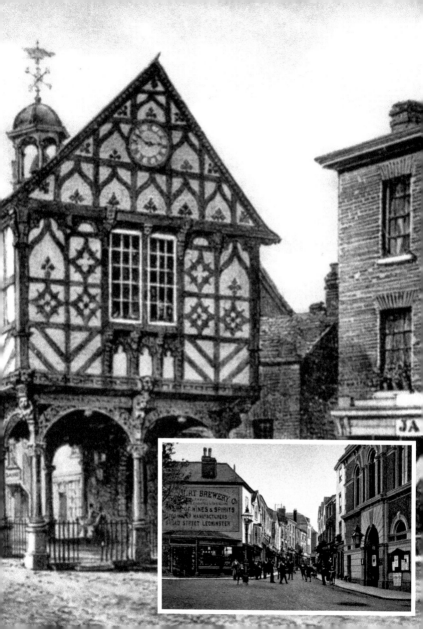

15. CHURCH STREET AND THE TOWN HALL

Another view of the Victorian Town Hall, this time from Church Street. The front part of the building held the Council Chamber. Behind this was a Market Hall where every Friday all sorts of county produce would be offered for sale. The building suffered a rather sad fate: the tower became unsafe and was removed in 1950, and the rest of the building was demolished in 1975.

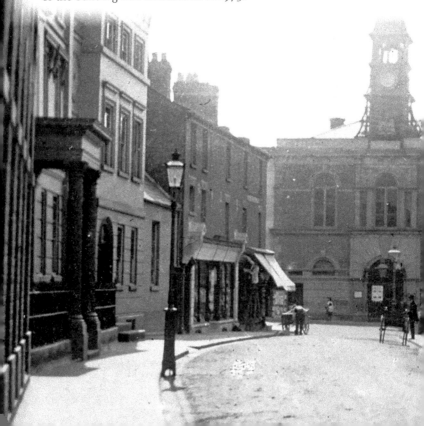

16. CHURCH STREET AND
THE FORBURY CHAPEL

Built in around 1284 near the gatehouse of the priory, the Forbury Chapel on the right is one of three surviving monastic buildings in the town. Over the years, it has been a parish church, the town gaol, civic hall, and a school. At the time of the photograph it was the office of solicitor Thomas Sale. The refurbished building is now used as a meeting place for church and community use.

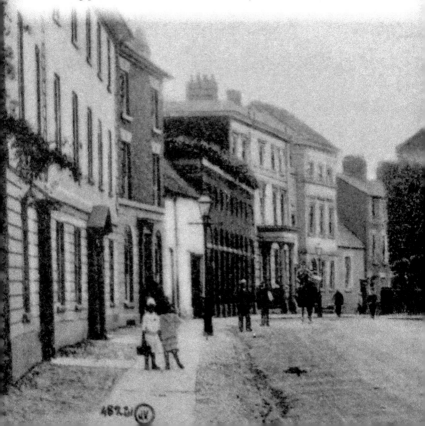

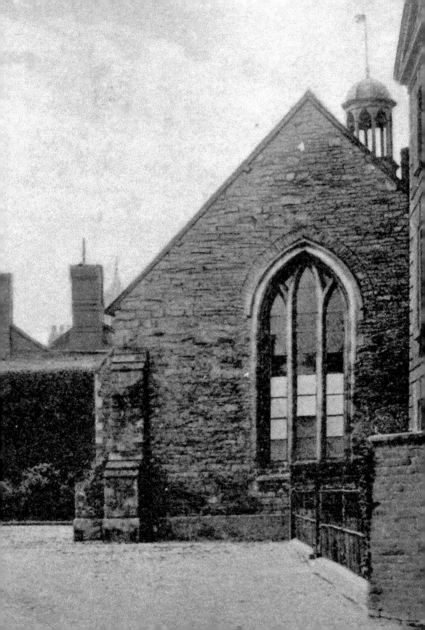

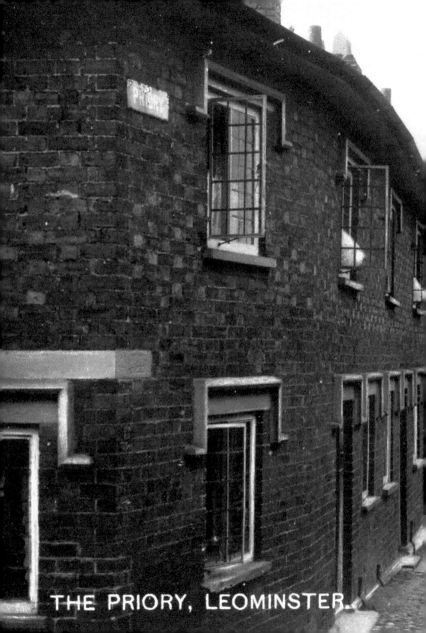

THE PRIORY, LEOMINSTER.

17. PRIORY LANE

This interesting group of houses line the lane running from the Kenwater footbridge towards the priory. Most of them date from the mid-1800s – built at around the same time as the bridge.

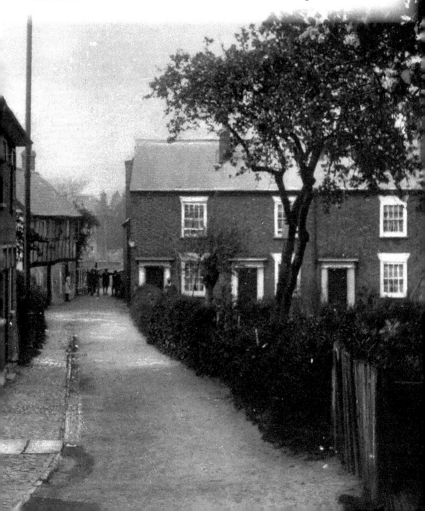

18. THE PRIORY HOUSE

Soon after this print was published in 1795, the Priory House became a goal before being incorporated as dayrooms and dormitories for the adjoining workhouse in the 1830s. The workhouse later became the Old Priory Hospital, then council offices, and is currently part of a youth hostel. Despite these changes, and having an attic inserted, the building retains many of its original features.

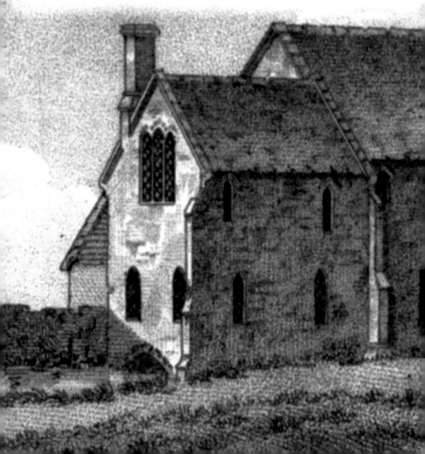

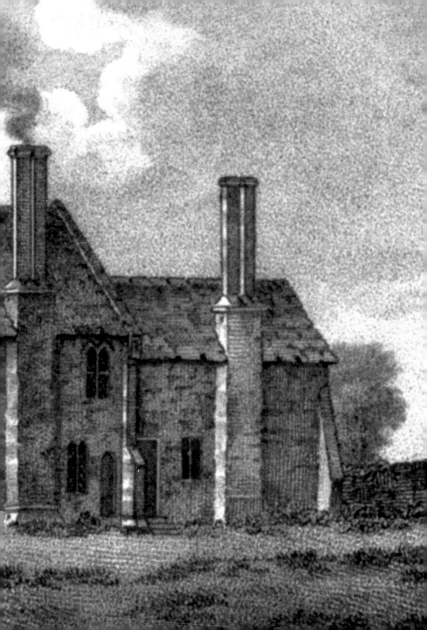

19. THE PRIORY CHURCH, FROM THE SOUTH-EAST

The oldest part of Leominster Priory is the north nave (visible on the far right). The inset photograph captures the appearance of the interior just before Sir Gilbert Scott removed the galleries, replaced the pillars between the central and southern naves, and moved of the organ to the south nave.

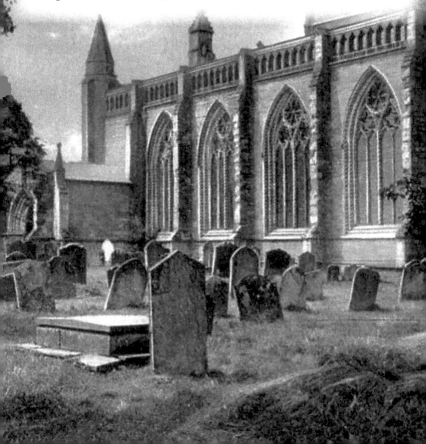

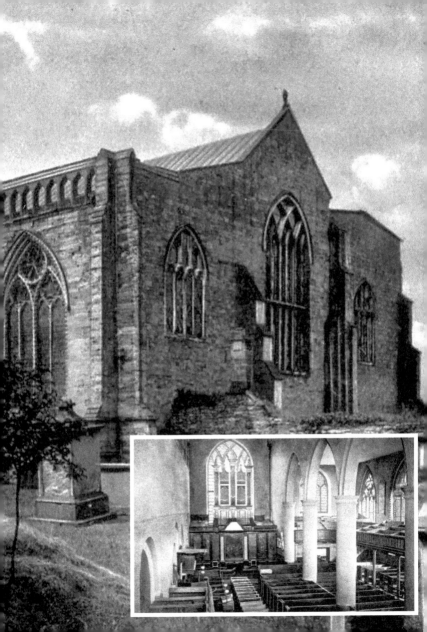

20. THE GRANGE

Since its move from Broad Street, the Grange has gone through a number of uses and is now run by a charity on behalf of the community. In the past, evening cricket matches here attracted hundreds of spectators, and the use of the cricket ground continued until concerns about safety forced the move to a new ground in Mill Street.

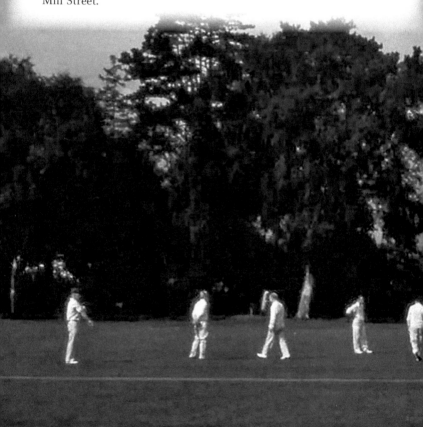

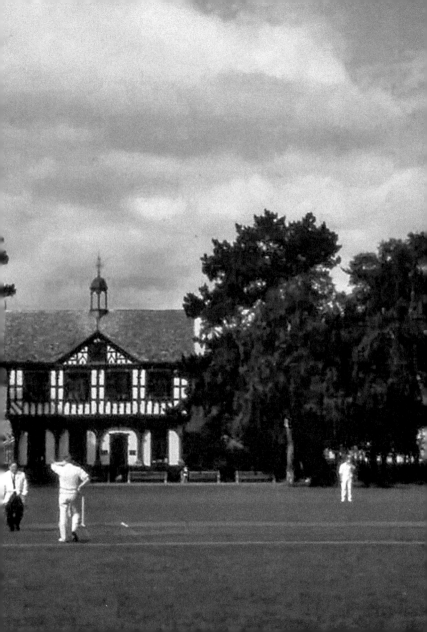

21. GRANGE HOUSE ACADEMY

Tucked into the south-east corner of the Grange, this building housed
a girls' school in the 1830s, and later became a boys' boarding school.
A pupil at the time recounted how the boys would often enjoy extra
holidays when the master was in drink and could not attend! The
school was later taken over by a Mr Cox and became a much more
reputable establishment.

22. PINSLEY MILL

The first cotton mill on this site was destroyed by fire in 1754, to be replaced by the corn mill in the picture. Plans to convert this building to residential use came to nothing and the building was demolished recently – a sad fate for this historic site, the last of the five corn mills once operating in Leominster. The inset shows the mill in 2012.

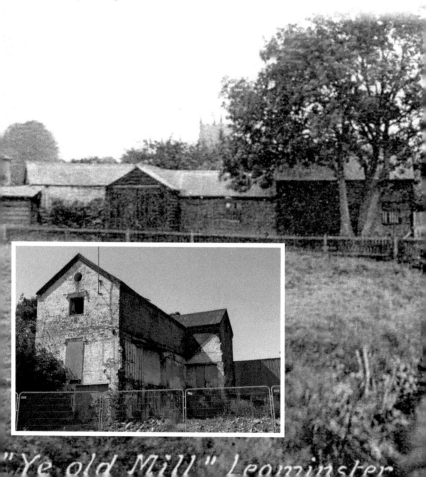

"Ye old Mill" Leominster

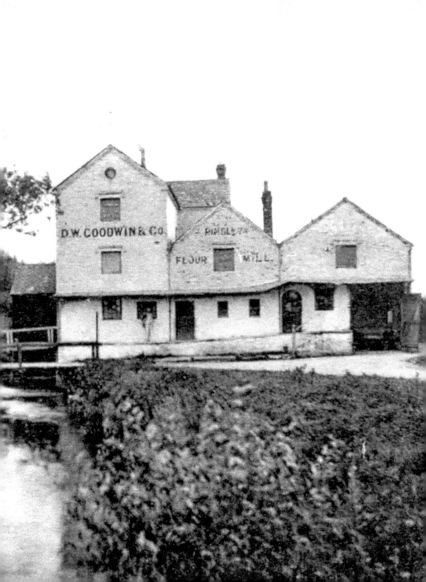

23. THE WHITE LION IN ETNAM STREET

When Henry Newman completed this sketch of the White Lion in around 1850, the eastern end of Etnam Street was just a quiet spot on the Worcester road. Built in the early 1500s, the original layout of this building is still visible today, although the nest holes for doves no longer adorn the gable wall and the Pinsley brook in the foreground has been covered over.

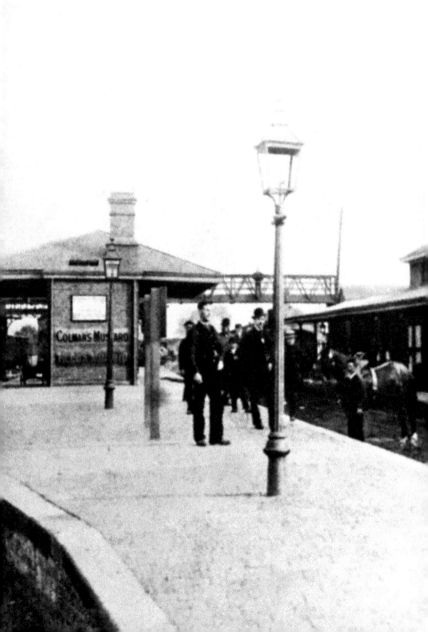

24. RAILWAY STATION, 1900

In its heyday, the station needed a large workforce and, from 1901, an elevated signal box to control the traffic. Today the signal box and all the lines bar one have gone and the station is just a halt on the Hereford to Shrewsbury main line. However, thanks a campaign by Leominster Council and the local Civic Trust, the station still has its Victorian buildings and canopy.

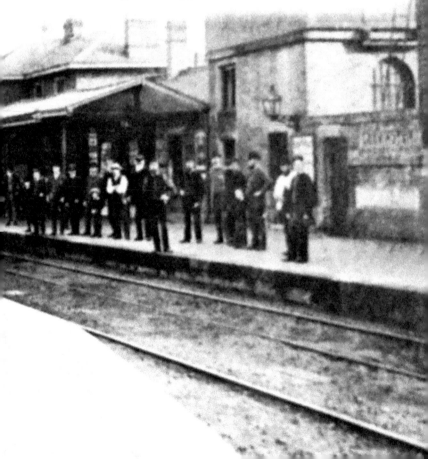

25. THE LOWER HALF OF ETNAM STREET, 1900

The Duke of Norfolk created the Dukes Walk in 1792 to make it easier for the residents of Etnam Street to reach the priory. The pub on the corner of the lane, the Dukes Arms, is almost as old. Across the road are the imposing double-bay windows of the Waverley Temperance Hotel, now the site of a care home.

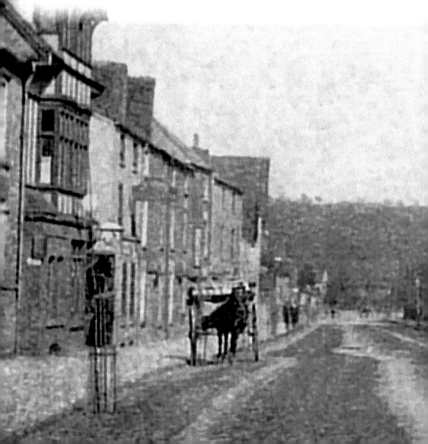

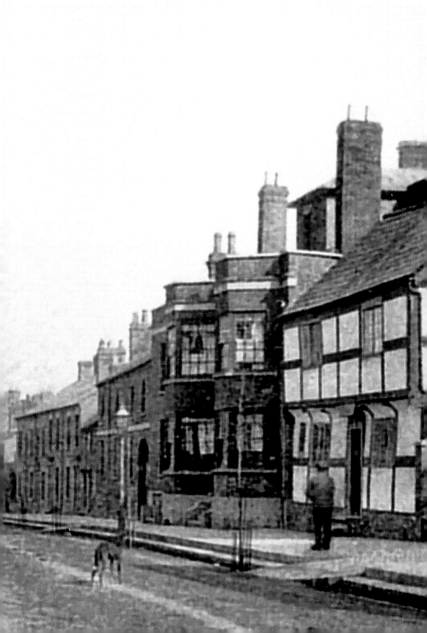

26. THE CHEQUERS INN, ETNAM STREET

James Biddle was landlord of the Chequers Inn when this photograph was taken between 1858 and 1879. The family remained in the house up until the 1930s when Harold Job Biddle was the landlord. The building itself dates from around 1600 and although extended and changed over the years, it has retained many of its original features. In 2007 it was named Herefordshire Pub of the Year by CAMRA.

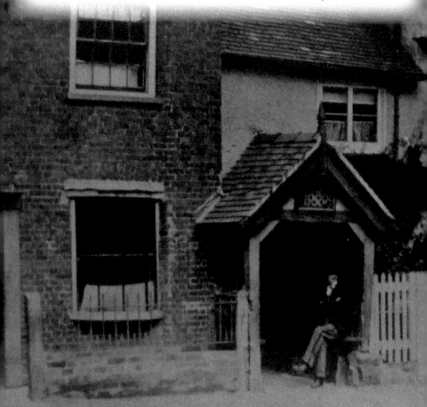

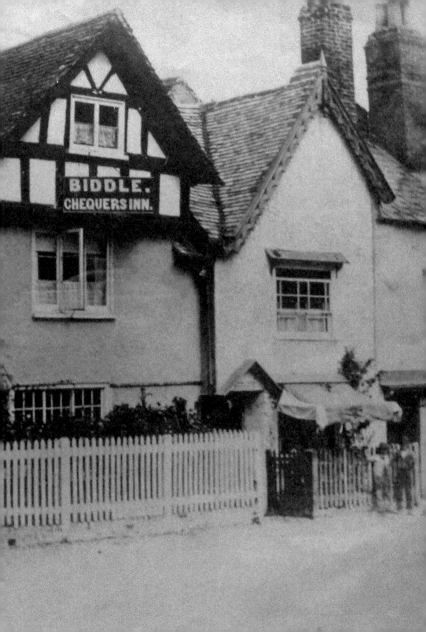

27. WATSON'S WORKSHOP – LEOMINSTER MUSEUM, ETNAM STREET

At one time Watson's occupied three buildings in Etnam Street: this former Mission Hall, a building across the road, and their current garage.

Opened in 1855, the Mission Hall went through a number of uses before being acquired by Leominster Museum in 1972. Run entirely by volunteers, the museum is open during the summer months.

WATSON'S
MOTOR WORKS LTD.
SALES & SERVICE.

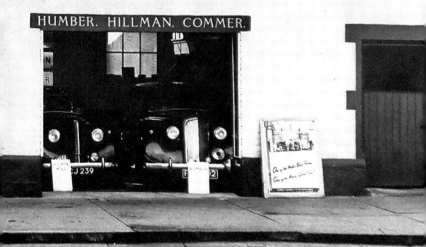

HUMBER. HILLMAN. COMMER.

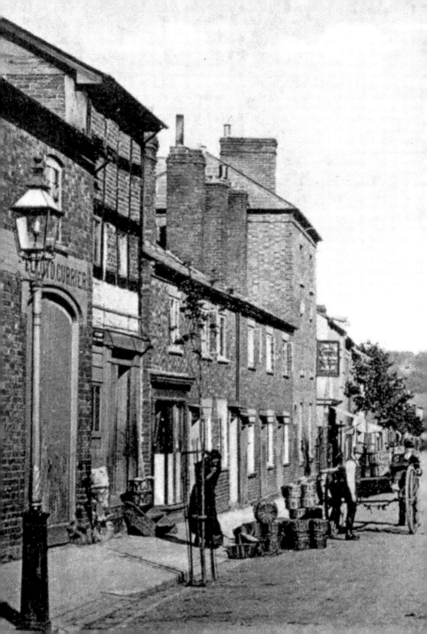

28. ETNAM STREET, WEST

The large sign for the Royal Oak Livery Stables is a reminder of a time when coaches would stop at this hotel. The smaller archway next to this has the name Thomas Lloyd, currier (or leather worker), above the door and gave access to the outbuildings at the rear of the Kings Arms, an important inn on the Corn Square in the eighteenth century.

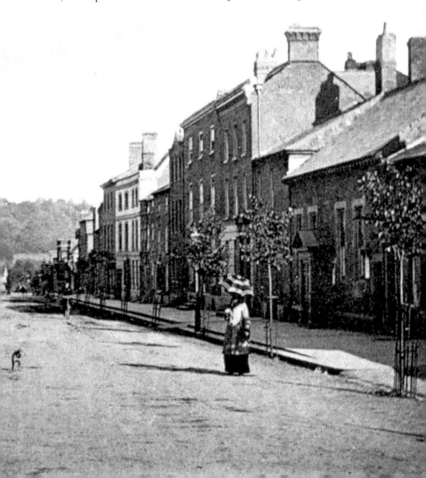

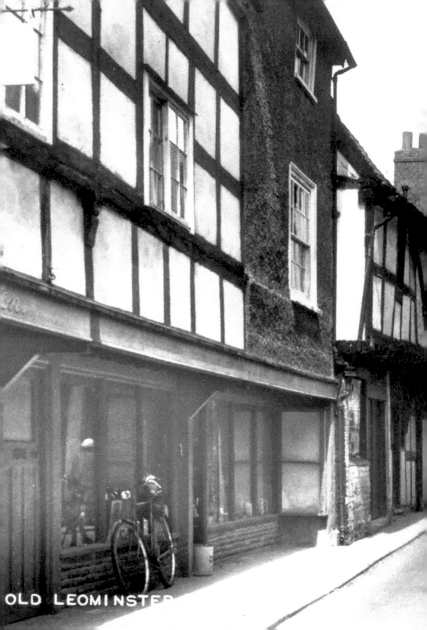

OLD LEOMINSTER

29. SCHOOL LANE, c. 1950

Today, this lane seems to have regained some of the bustle and activity missing from this picture. Many older residents of the town will remember with affection McEwans café on the left, or the cosy shop on the right where Mr Young could be found at work, his mouth full of nails ready to drive into the sole of another boot in need of repair.

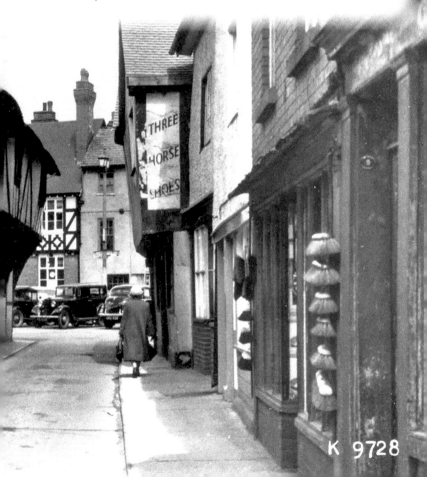

K 9728

30. CORN SQUARE, SOUTH SIDE, 1950s

Thankfully, this much-photographed group of fifteenth-century buildings still grace Corn Square. The shops have changed occupants of course, and the former Three Horse Shoes pub on the corner has become a coffee shop.

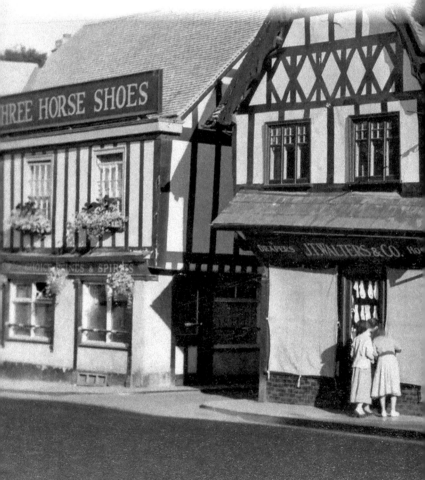

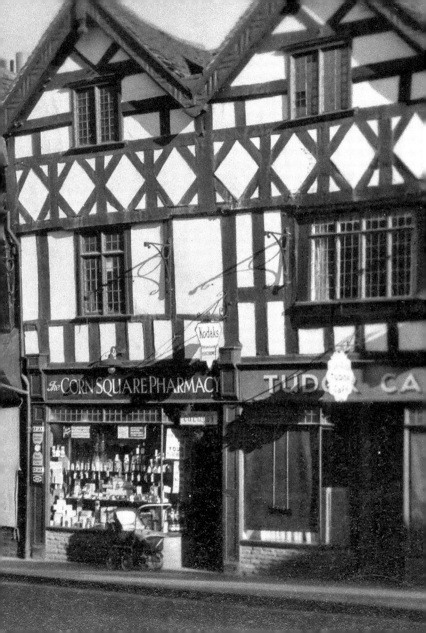

31. THE CORN EXCHANGE, LATE 1800s

Originally built as a market house in 1859, the hall of this imposing building could hold 500 people and served as a space for balls, concerts, and films. The advert for the film *Alfie* in the inset dates it to 1966, shortly before its demolition. Its replacement continues to arouse fierce debate, as does the addition to the gable of a clock featuring the ducking stool to mark the millennium.

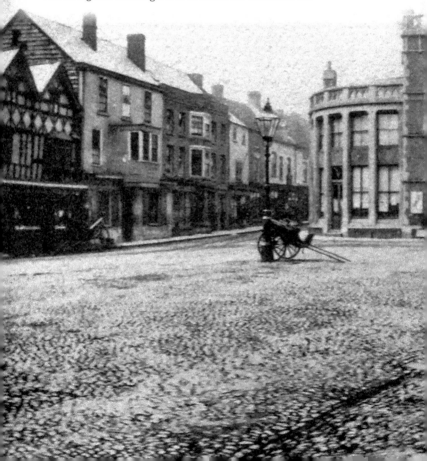

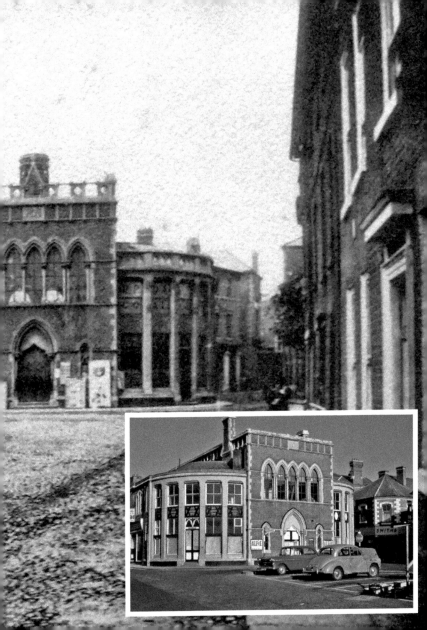

32. CORN SQUARE, NORTH SIDE, 1940s

Two of the buildings in this 1940s view were the subject of public campaigns to retain them when threatened with closure. The first was a spirited, but unsuccessful, defence of the post office in 2006. The second, following the withdrawal of funding in 2011, was successful in saving the tourist information office.

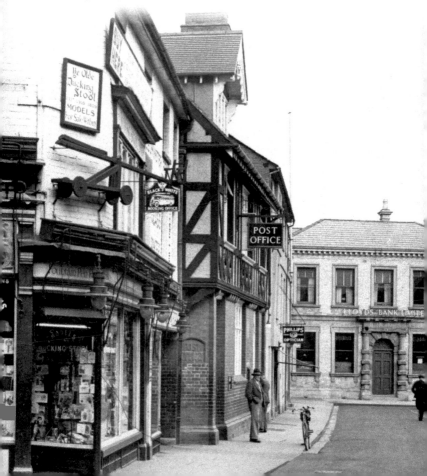

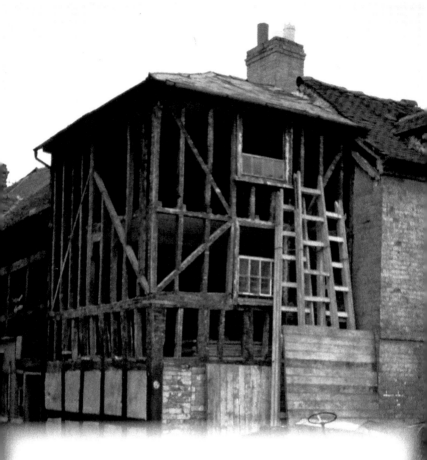

33. MERCHANTS HOUSE, 1970

This photograph shows the Merchants House stripped back to its frame during renovation. Unfortunately far too many of the old buildings in the town have been lost. As Norman Reeves noted in his *The Town in the Marches,* 'Those who like the restorer of the Old Merchants House in the Corn Square preserve rather than replace are the real benefactors of the town.'

34. DRAPERS LANE

Originally, Drapers Lane and the High Street marked the edges of a large triangular marketplace, onto which the shops and houses on the left later encroached to create the narrow lane we see today. The Leominster Press on the corner of Drapers Lane and Corn Square not only sold newspapers, trinkets, and stationery but until the 1980s also produced the local paper, the *Leominster News*.

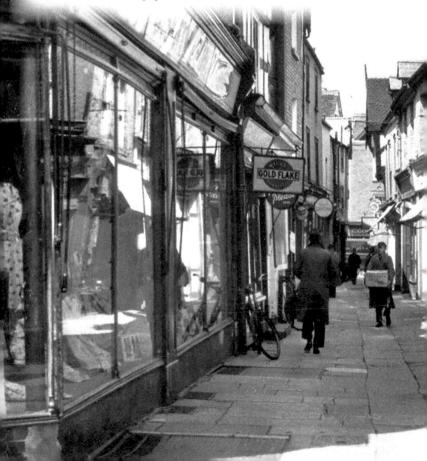

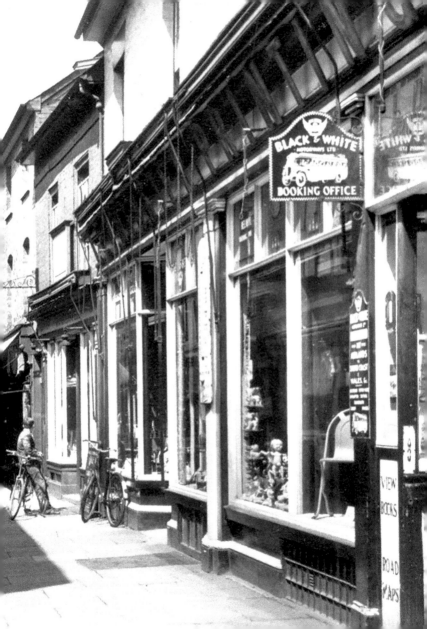

35. BARBER & MANUEL, VICTORIA STREET

Richard Scudamore, a ladies and gentleman's tailor, moved into this building when the post office moved out in 1908. The next occupants were the greengrocers Barber & Manuel and their adverts feature prominently in pictures of the Corn Square in the 1940s. The shop has retained the name and is now a delicatessen and café.

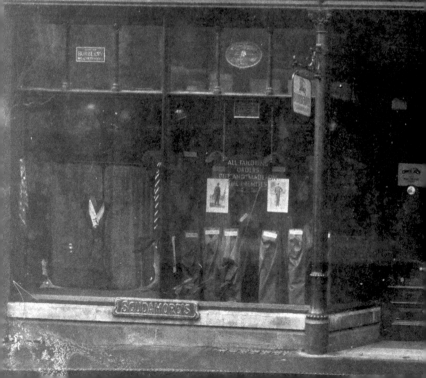

36. VICTORIA STREET

Victoria Street is one of the newer thoroughfares in the town centre, created in 1885 by widening existing alleyways and removing buildings. The photograph appears to have been taken during the summer, as the fishmonger is advertising a 'cool chamber during the hot weather' in his open-fronted shop. Few customers seem to be shopping – perhaps they are being kept away by the rain.

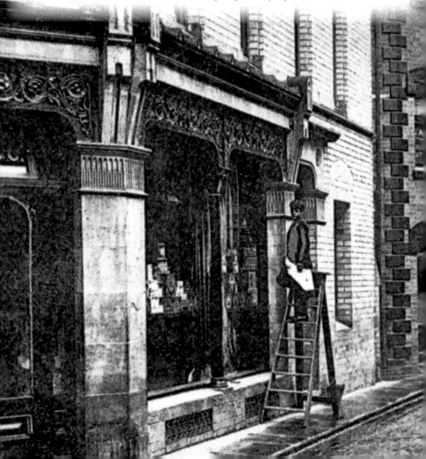

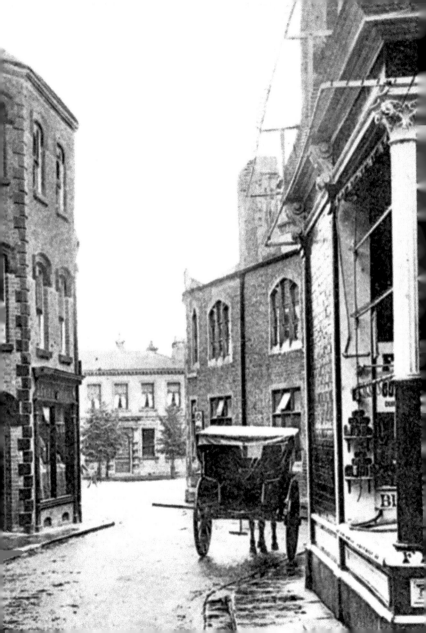

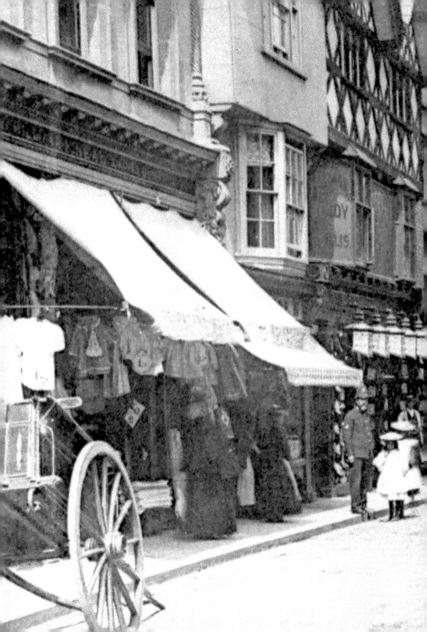

37. THE HIGH STREET

The clock on the right in this picture from the early 1900s marks the shop of William Wood, watch and clockmaker. Further on is a 'shaving' sign for a barber – a reminder of a time when most men would have a shave at the barbers rather than at home. Across the road is Freeman Hardy and Willis, a company that retained a shop on this high street up to the mid-1990s.

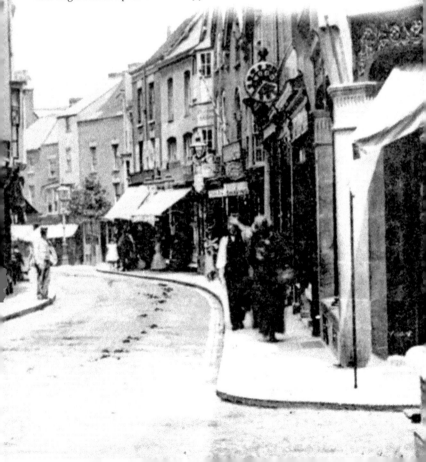

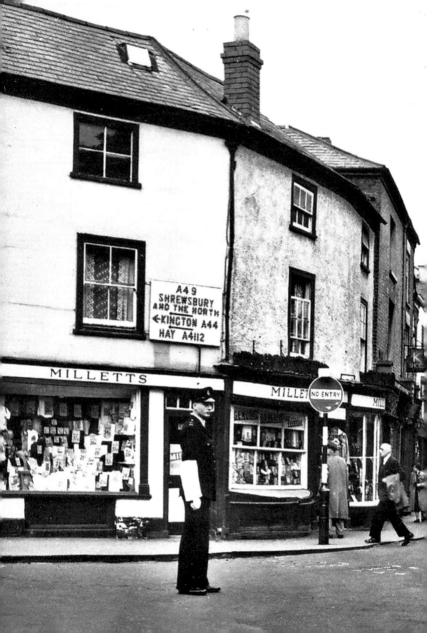

38. IRON CROSS, 1950s

This corner has always been the busiest and one of the most photographed parts of the town centre. Before the building of the bypass this notorious bottleneck often needed a police officer on point duty to keep the traffic flowing.

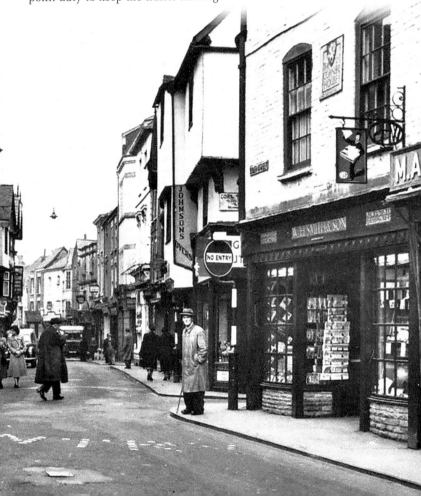

39. WEST STREET, 1950s

This scene brings back memories for many of a quieter time. A little girl on her tricycle concentrates on negotiating the corner past Hinton's Café, while a schoolboy in shorts has to wait patiently while his parents admire the jewellery on display in Reg Mayall's window. The shops here continue to be an interesting mix of small independent traders – and the telephone box is still there.

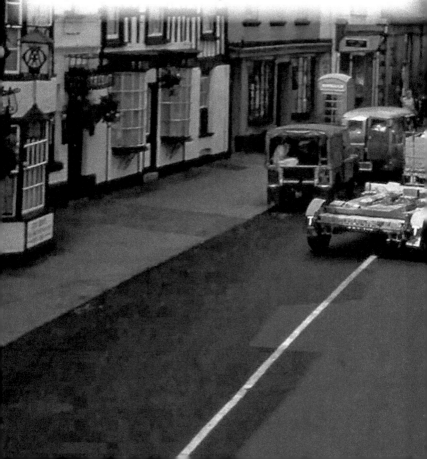

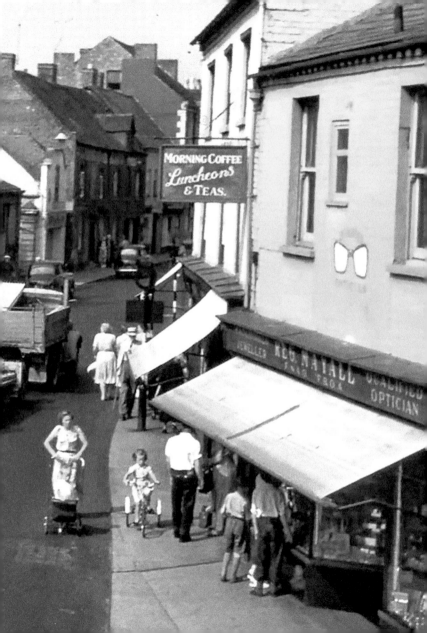

40. WEST STREET, LOOKING BACK TOWARDS IRON CROSS

The awning on the left at No. 44 advertises the premises of Abraham Pool, cabinetmaker and upholsterer, in this view from around 1910. The large chimney on the left is probably part of Alexander and Duncan's Vulcan Foundry. This was a brass and iron foundry and manufactured implements for the agricultural market.

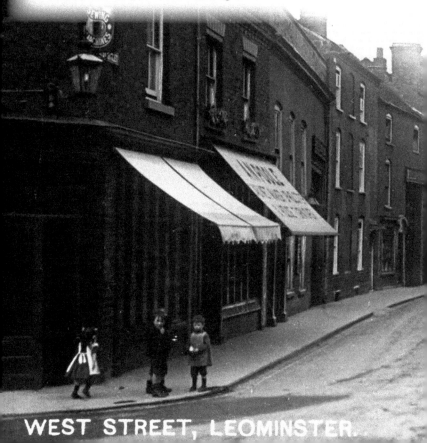

WEST STREET, LEOMINSTER.

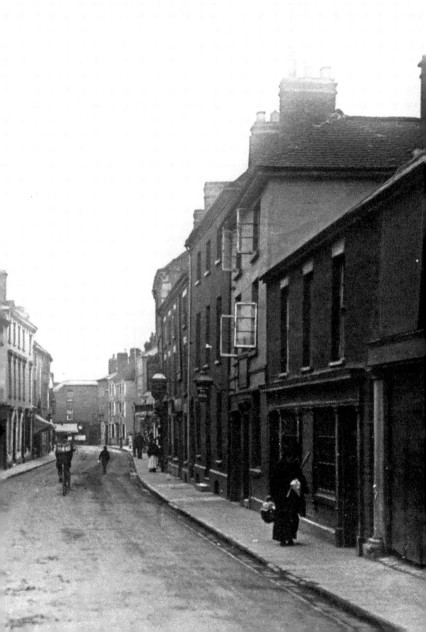

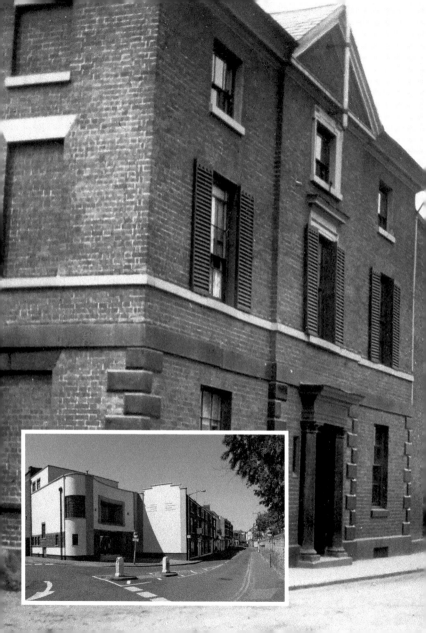

41. SOUTH STREET, c. 1900

At times, this street would be full of people and animals during regular livestock sales. The rather imposing buildings at Nos 28 and 30 South Street housed offices for solicitor Edwin Preece Lloyd. Number 30 was demolished in 1936 and replaced by the Clifton Cinema. The large stone set into the roadside was to stop coaches cutting the corner and hitting the building.

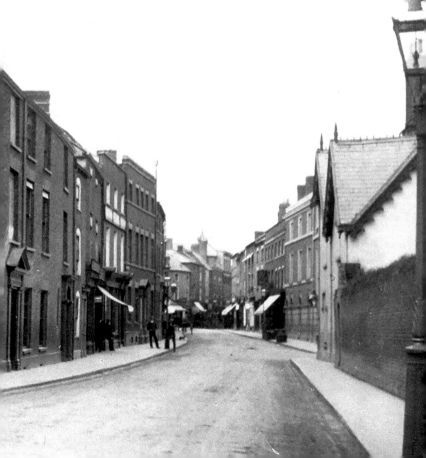

42. SOUTH STREET

The building on the left was the Quakers Meeting House, an influential force in the town in the nineteenth century. Beyond is Fryers Garage, now the site of the car park for the British Legion Hall. Across the road is the brewery with its distinctive archway. This was modified to become a Masonic lodge in 1929.

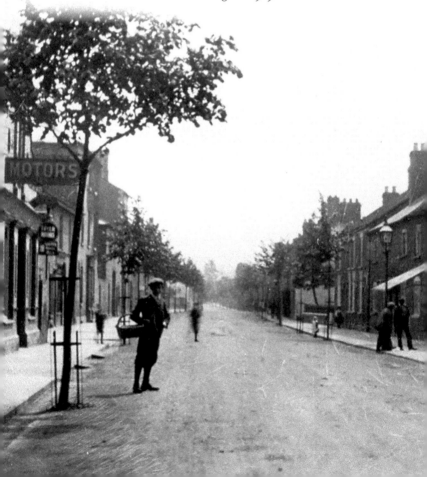

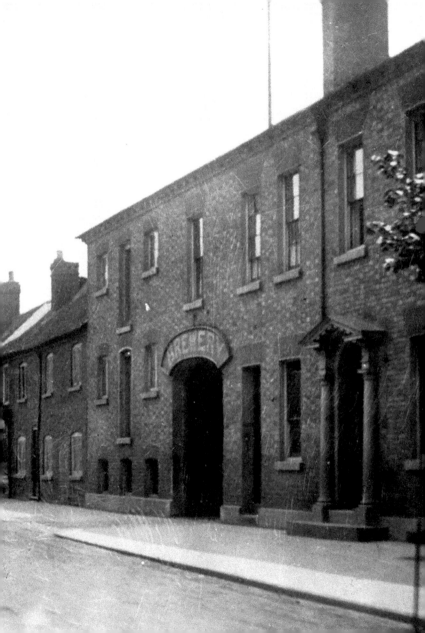

43. MORAVIAN CHAPEL

Tracing their history back to 1415, the Moravians came to England in the early eighteenth century following persecution on the continent. The chapel in Leominster was consecrated in 1761. In this photograph from around 1910 a group from the church, including the pastor, prepare for an outing. Although numbers have declined from their peak, the church building is still used for services every Sunday.

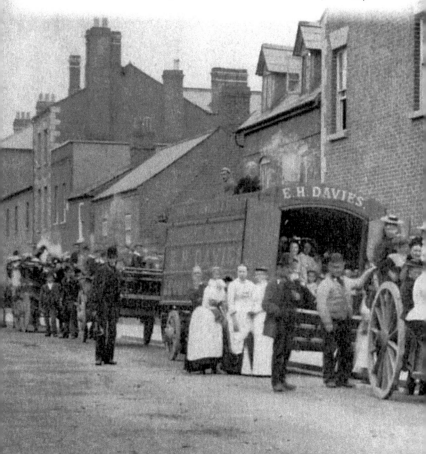

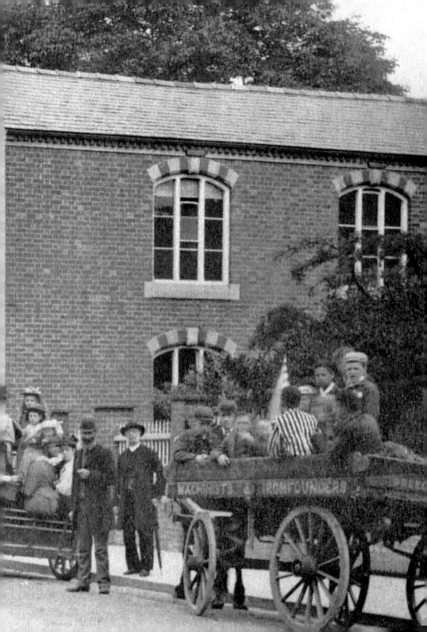

44. COTTAGE HOSPITAL

This photograph shows Cottage Hospital on South Street after the addition of an upper floor to the 1899 single-story building. The proceeds of the first performance at the new cinema were donated to the hospital, (*see* No. 41). Each autumn during the local hop harvest, many yards would have a crib where pickers could donate part of their work to the hospital.

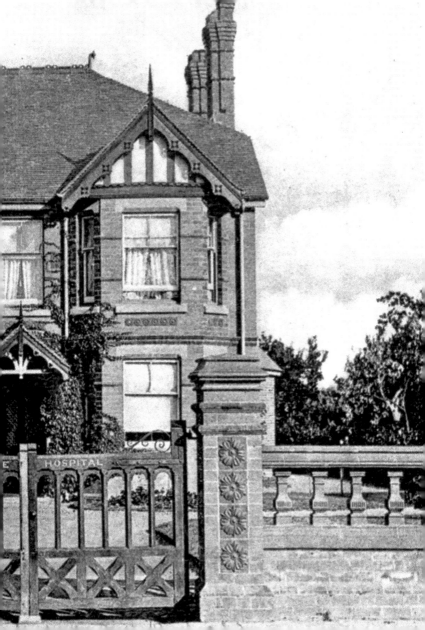

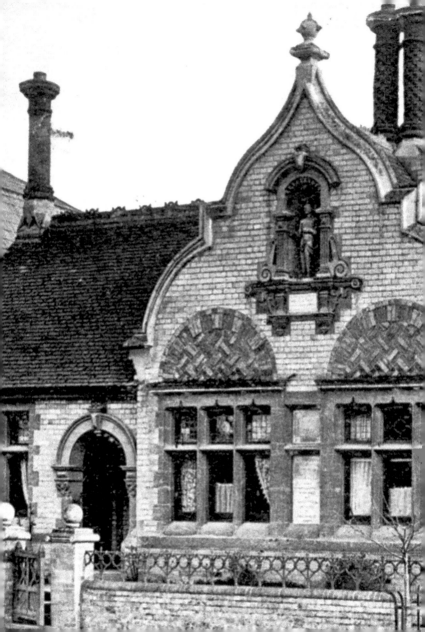

45. HESTER CLARK'S ALMSHOUSES

Founded in 1735 to provide accommodation for 'four decayed widows', these houses were rebuilt in 1874 and today are still managed by the almshouse charity. There is a plaque featuring an axeman on the front with the lines 'He that give away all before he is dead, let them take this hatchet and knock him on ye head'. This is supposed to refer to the financial difficulties caused to the founder by building them.

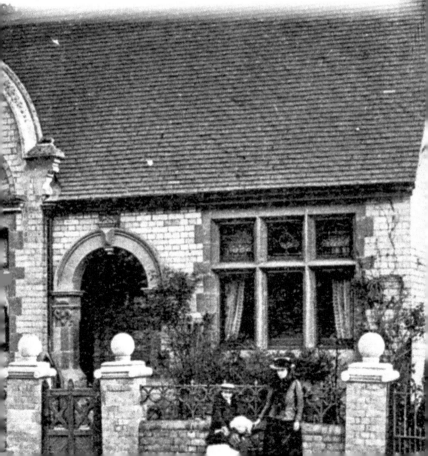

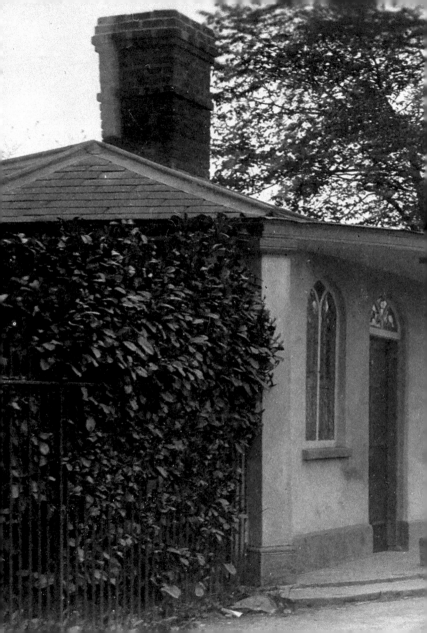

46. TOLL HOUSE, RYELAND ROAD

Most of the roads around Leominster were brought under the control of a turnpike trust in 1729, and tolls were collected for their upkeep. The toll house on the Ryelands road was one of six around Leominster. They were all sold in 1869, made redundant by the coming of the railways, and most were demolished.

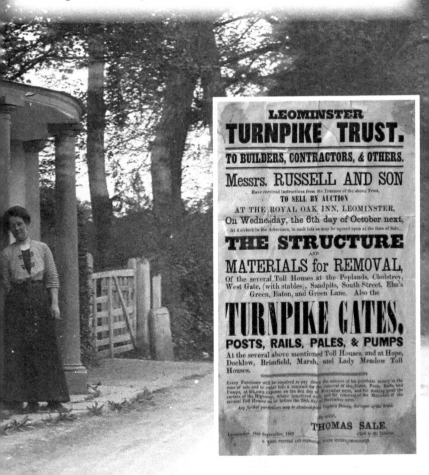

LEOMINSTER
TURNPIKE TRUST.

TO BUILDERS, CONTRACTORS, & OTHERS.

Messrs. RUSSELL AND SON

Have received Instructions from the Trustees of the above Trust,

TO SELL BY AUCTION
AT THE ROYAL OAK INN, LEOMINSTER,

On Wednesday, the 6th day of October next,

At 4 o'clock in the Afternoon, in such lots as may be agreed upon at the time of Sale,

THE STRUCTURE
AND
MATERIALS for REMOVAL,

Of the several Toll Houses at the Poplands, Cholstrey, West Gate, (with stables), Sandpits, South Street, Elm's Green, Eaton, and Green Lane. Also the

TURNPIKE GATES,
POSTS, RAILS, PALES, & PUMPS

At the several above mentioned Toll Houses, and at Hope, Docklow, Brimfield, Marsh, and Lady Meadow Toll Houses.

Every Purchaser will be required to pay down the amount of his purchase money at the time of sale and to enter into a contract for the removal of the Gates, Posts, Rails, and Pumps, at his own expense on the 3rd day of November next, and for making good the surface of the Highway, where interfered with, and for removing all the several Toll Houses on or before the 20th day of November next

Any further particulars may be obtained from Captain Decoy, Surveyor of the Trust

By order,
THOMAS SALE,
Clerk to the Trustees

Leominster, 18th September, 1869.

B. WARD, PRINTER AND STATIONER, HIGH STREET, LEOMINSTER.

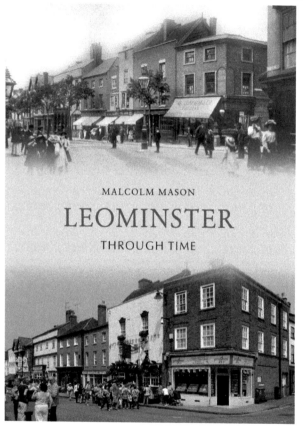